Growing up

the dog years

A Bark & Smile® Book

Photographed by Kim Levin
Written by John O'Neill

**Andrews McMeel
Publishing**

Kansas City

04 05 06 07 08 WKT 10 9 8 7 6 5 4 3 2 1

ISBN: 0-7407-4195-0

Library of Congress Control Number: 2003113022

Book design by Holly Camerlinck

www.barkandsmile.com

Attention: Schools and Businesses

Andrews McMeel books are available at quantity discounts with bulk purchase for educational, business, or sales promotional use. For information, please write to: Special Sales Department, Andrews McMeel Publishing, 4520 Main Street, Kansas City, Missouri 64111.

For Ian

Acknowledgments

Growing Up is our third collaboration, and we had a blast putting this book together. We would like to thank Dorothy O'Brien, our editor, and Andrews McMeel, for continuing to support the Bark & Smile line of books. Thank you also to Jim Hutchison for his impeccable developing skills.

Finally, we wouldn't be able to do what we do without the help of our four-legged friends. It's their humor that truly inspires us.

During childhood,

we wish we were big.

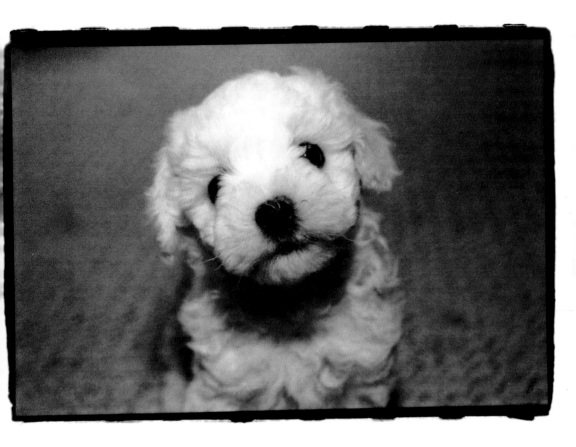

So we make up for our height with a "tall" attitude.

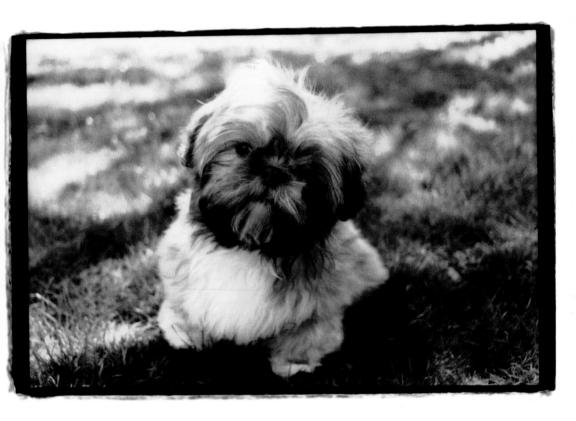

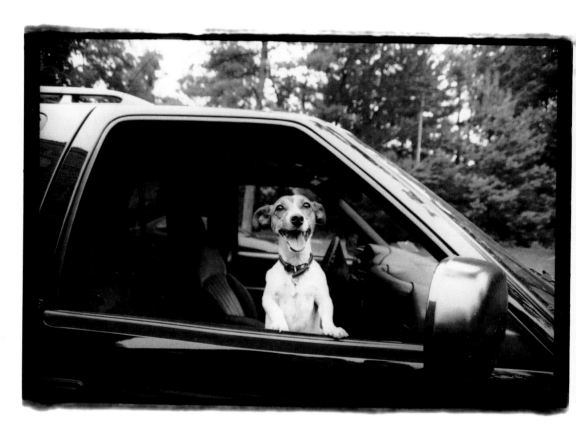

We love rides, as long as we "get there" quickly.

There's lots of sibling rivalry.

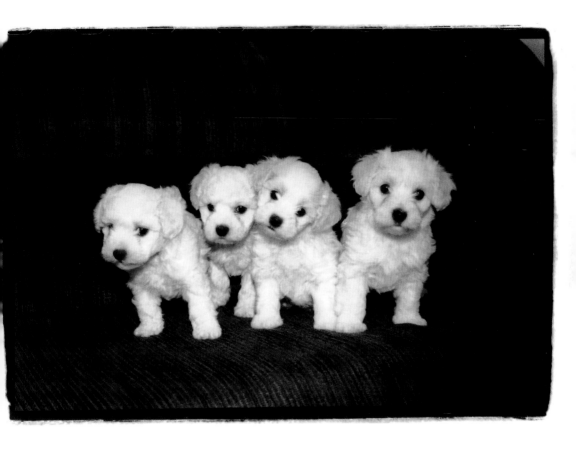

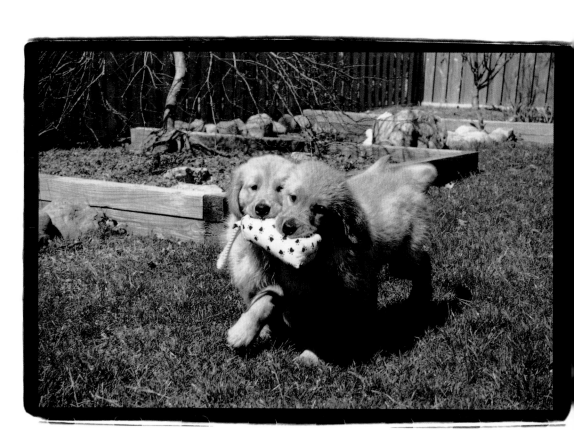

But we learn to share our toys.

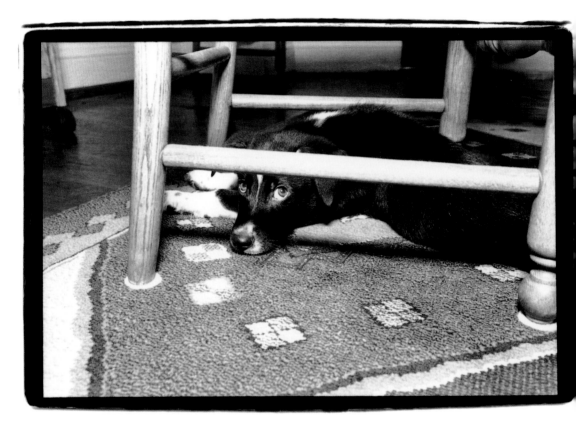

We'll do anything to avoid going to bed.

We approach life with curiosity.

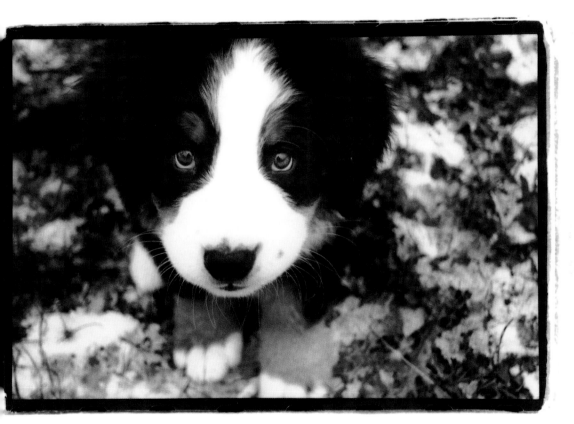

We use our "cuteness" to get attention.

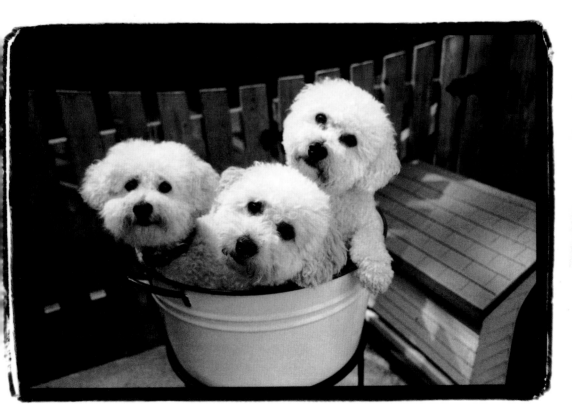

Some of us are outgoing.

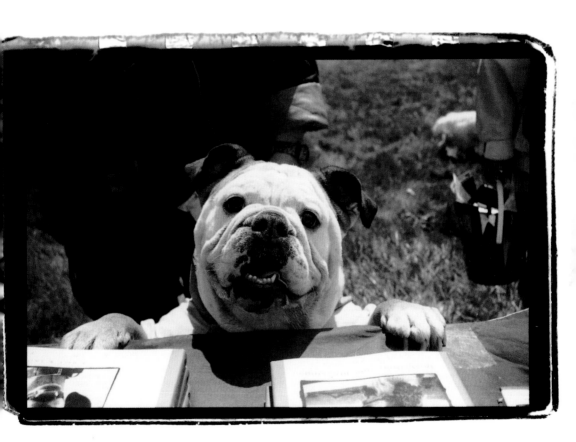

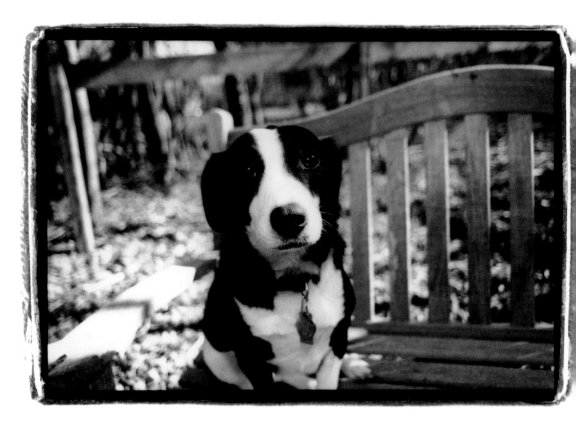

And some of us are shy.

But we always welcome new faces.

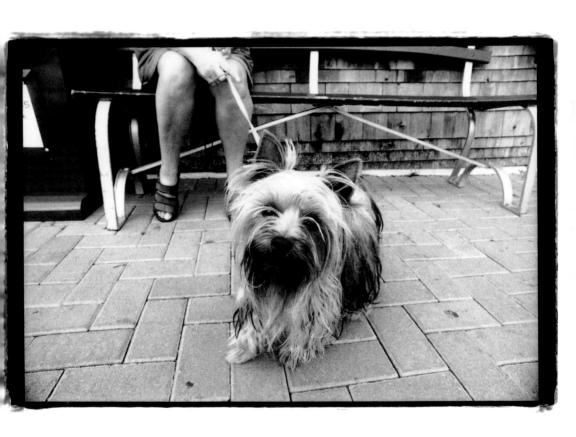

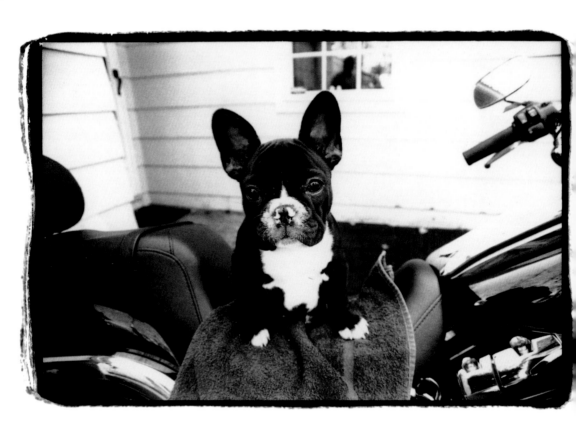

We think motorcycles are cool.

We're full of pep.

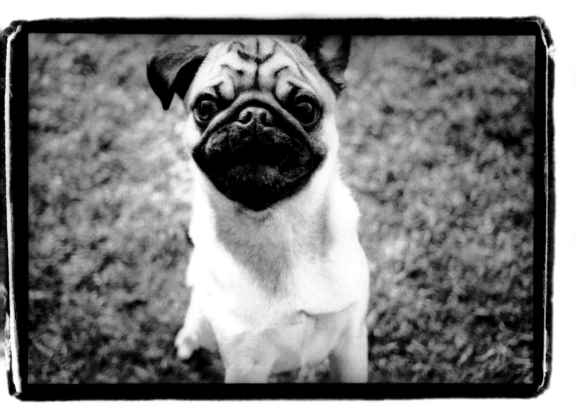

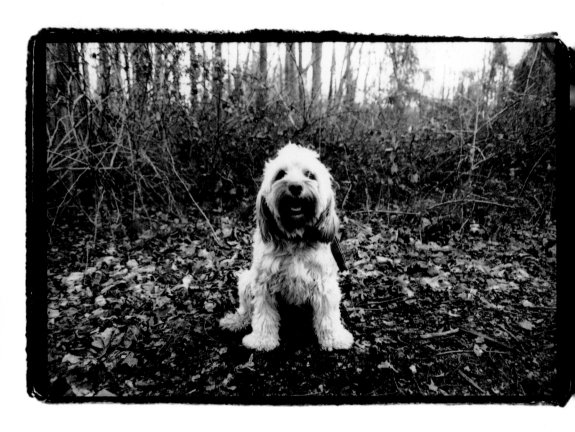

We like to play outside.

We don't have a care in the world.

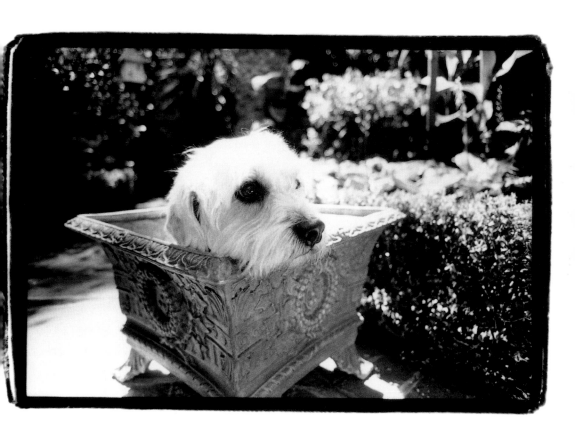

Then, all of a sudden, we start to grow fast.

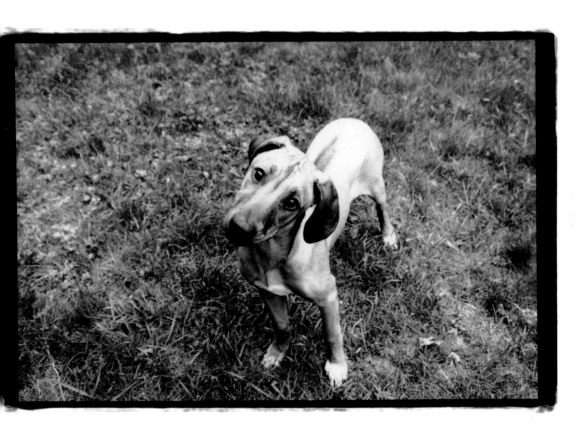

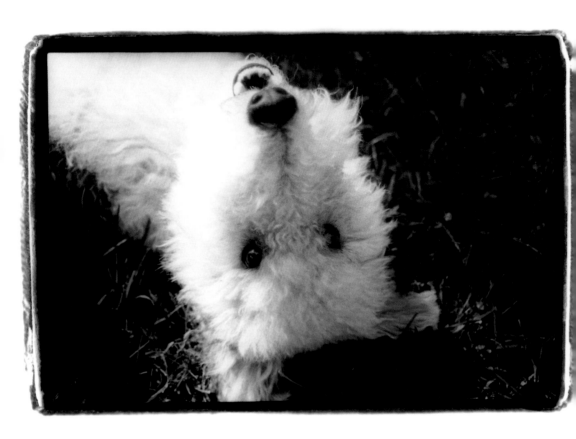

Sometimes our heads outgrow the rest of us,
and our bodies need to catch up.

We go through that awkward stage.

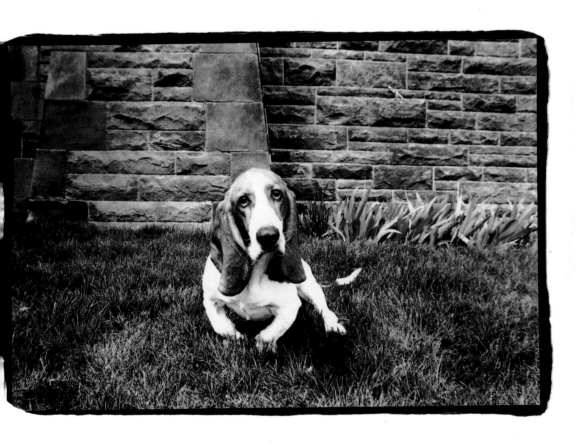

We try to be different from the rest.

We wonder what we'll be when we grow up.

Maybe a professional ball player . . .

or even a rock star.

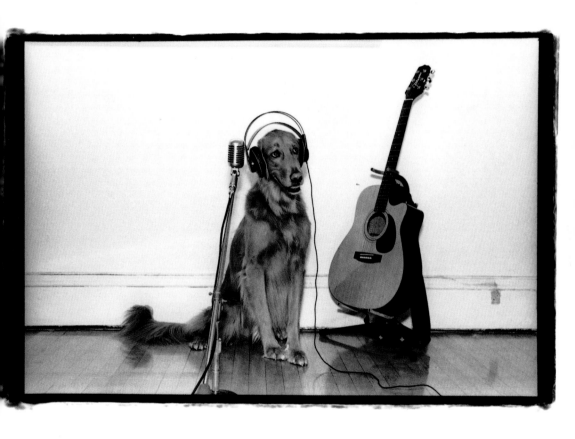

We experience "puppy love."

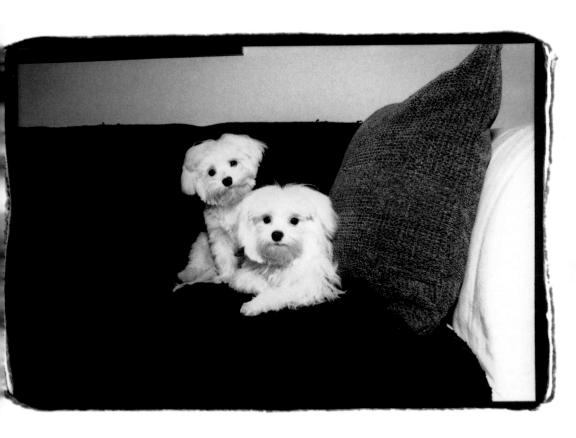

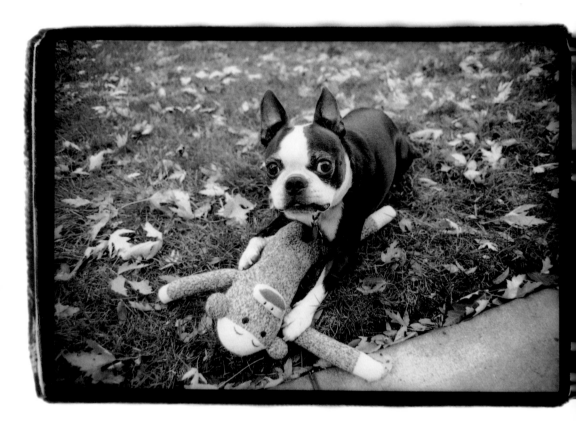

We practice our pick-up lines.

We spend hours on our hair.

Our braces finally come off.

School takes a backseat to fashion.

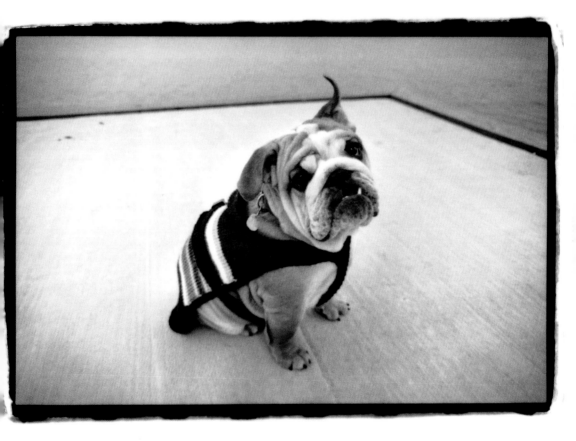

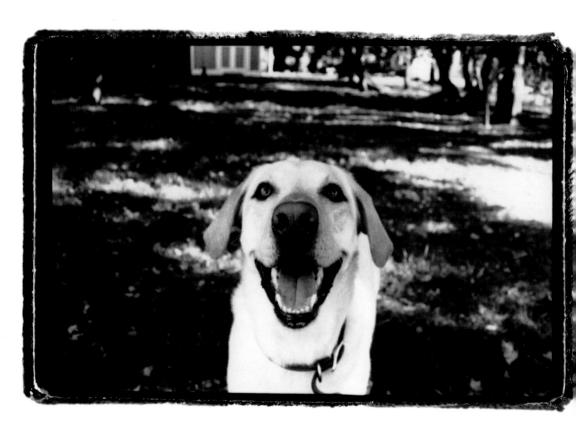

We live in the moment.

Nostalgia hasn't even entered our vocabulary.

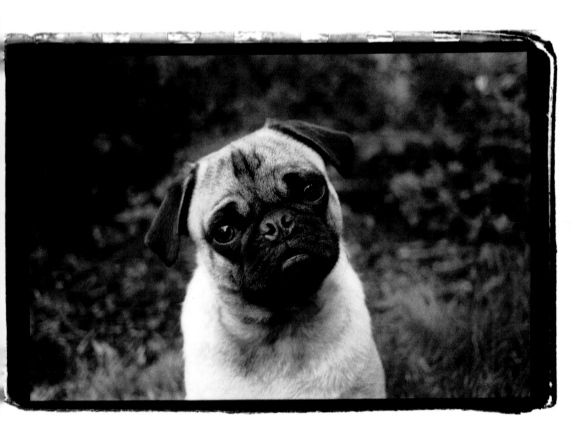

When we reach
adulthood . . .

we're finally big!

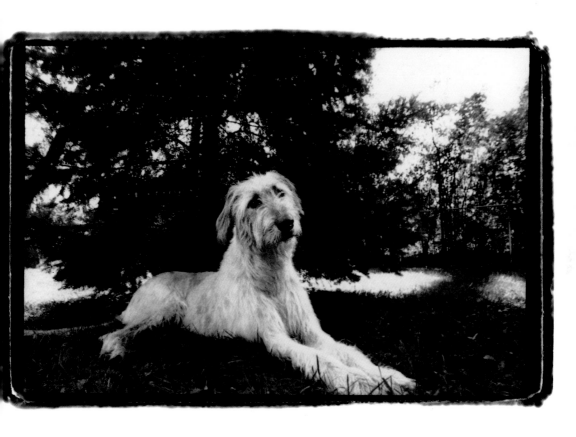

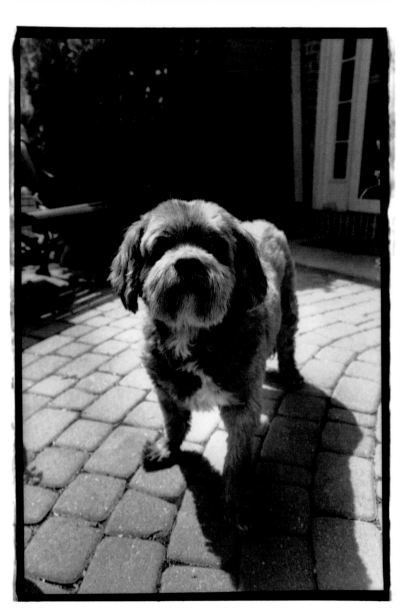

Well . . . not all of us.

Our "tall" attitude is now referred to as "short man's disease."

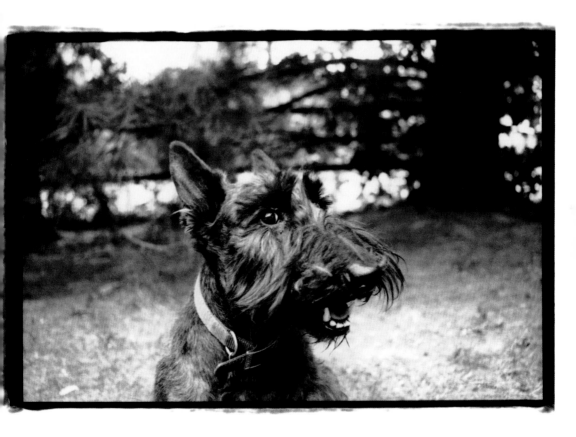

To get attention, we're forced to use our wit.

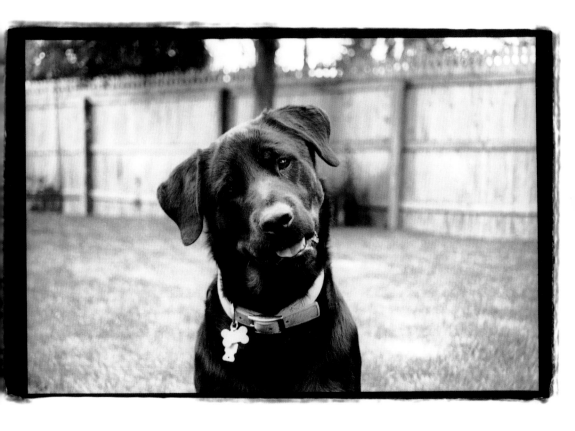

We approach life "head-on."

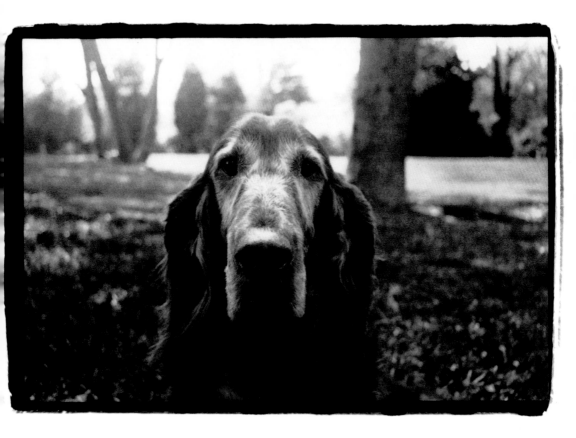

We settle into a career.

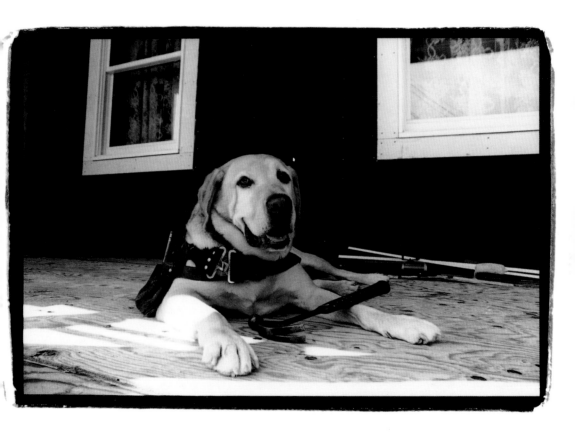

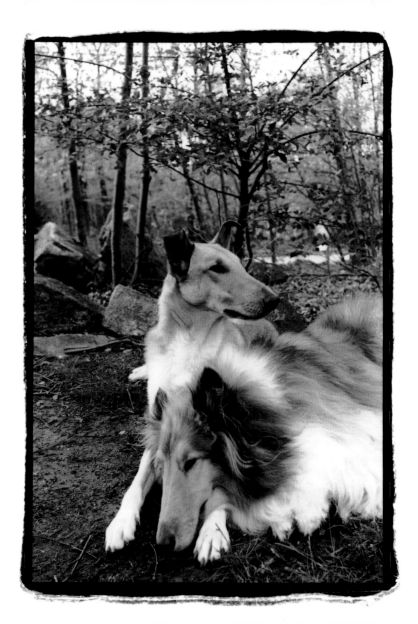

We get over our crushes,
and hopefully find a soul mate.

We become more reserved.

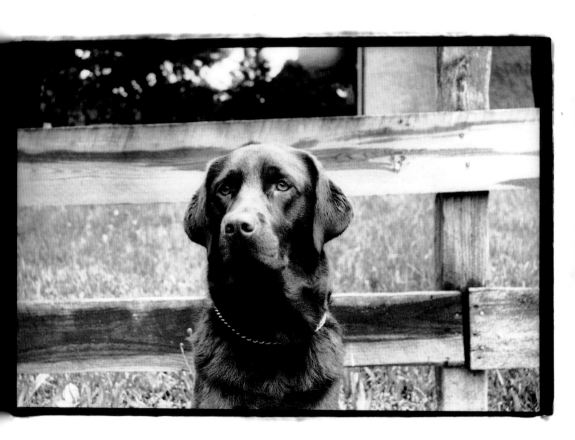

We try harder to blend in.

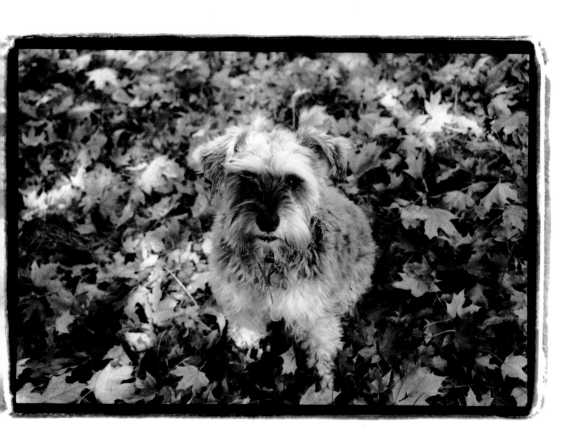

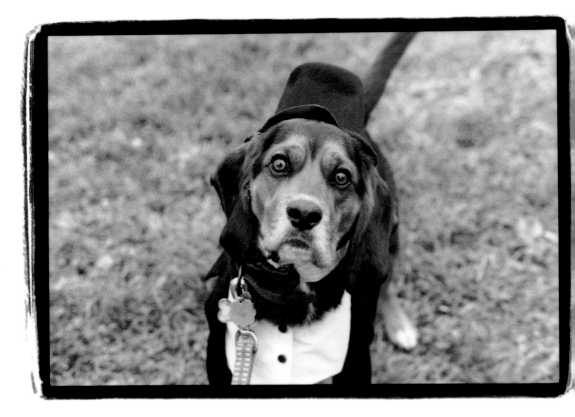

We hit the social scene.

We start a family . . .

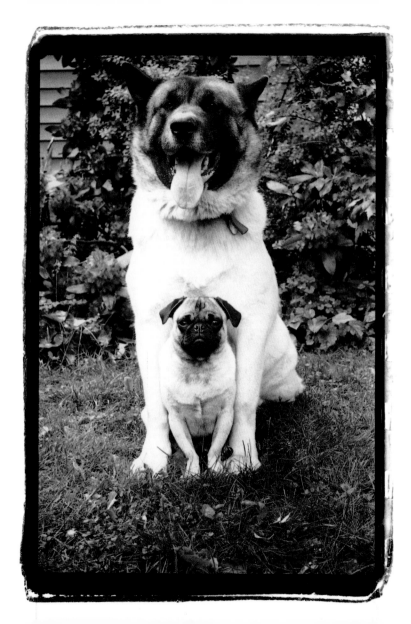

and share our love and wisdom.

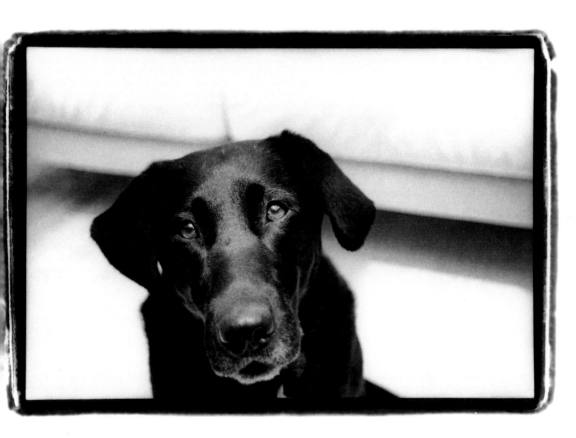

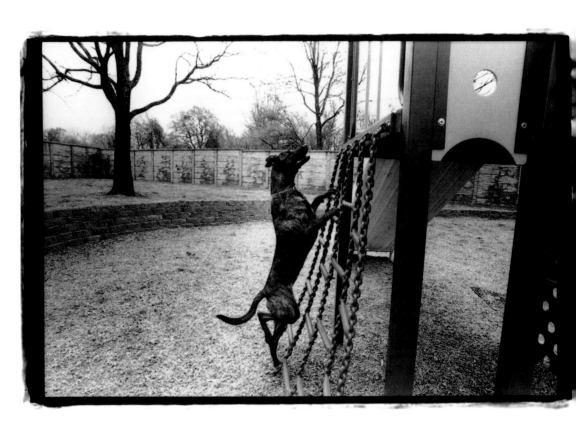

Staying in shape becomes a challenge . . .

especially if our health takes a lunch break.

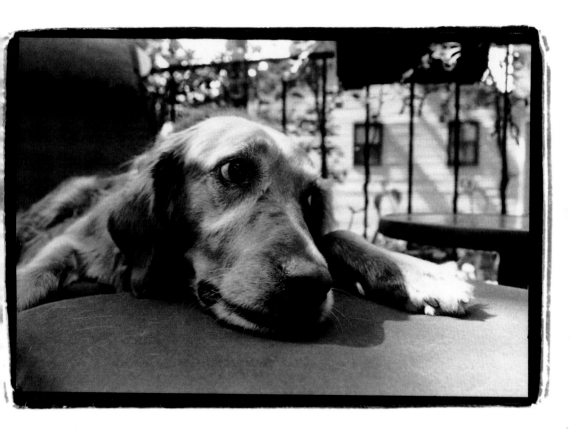

For some of us,
playing outside is a rare treat.

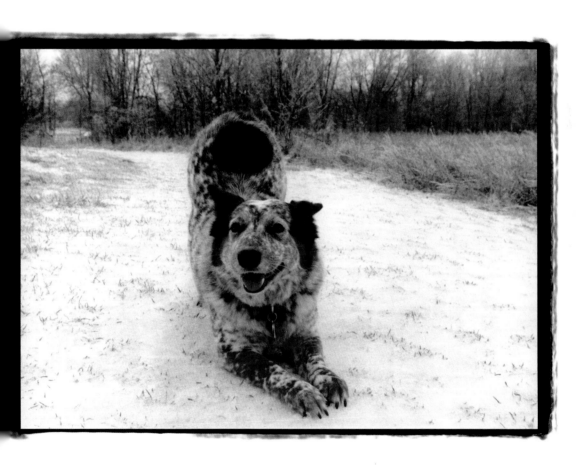

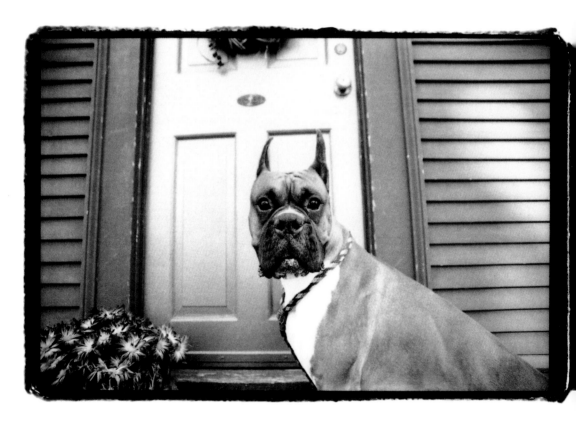

We tend to stay closer to home.

We become nosy neighbors.

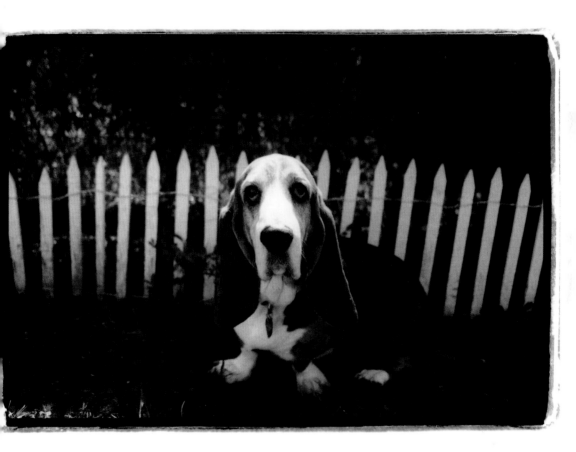

It gets harder to stay up past 10 P.M.

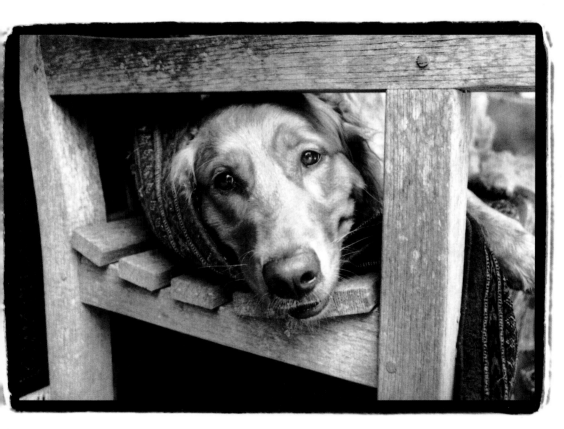

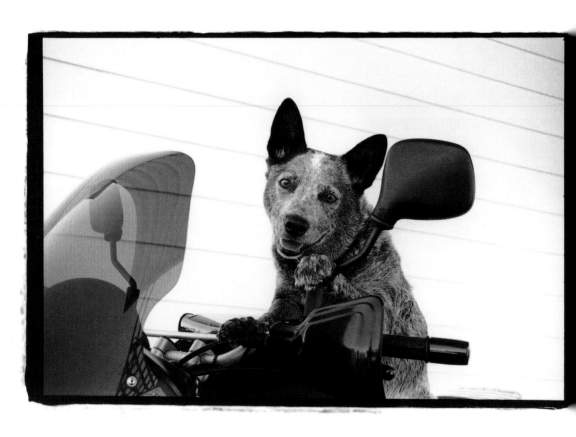

We still think motorcycles are cool . . .
and they sure come in handy during a midlife crisis.

We start thinking about that
inevitable dye job.

Some of us even tell our stylist
to try something different.

The only things that keep growing

are our noses . . .

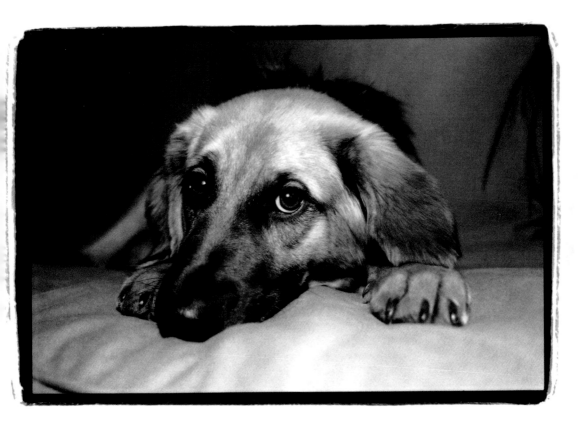

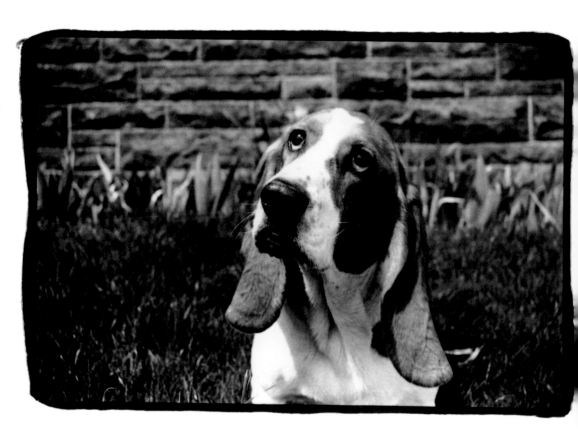

and our ears.

Before we know it, we're "empty nesters."

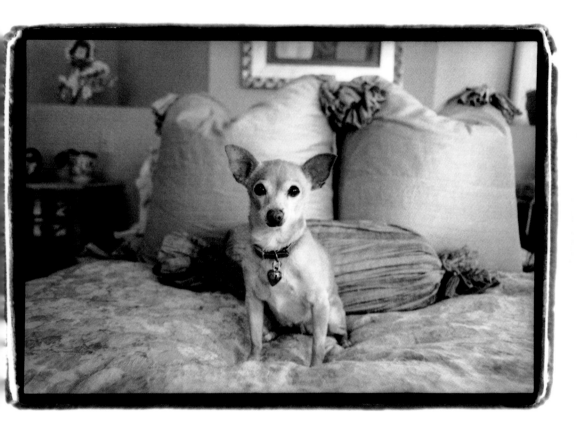

As retirement looms, we buy new toys.

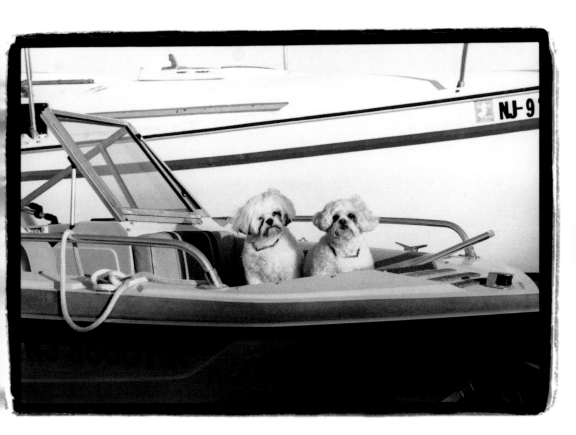

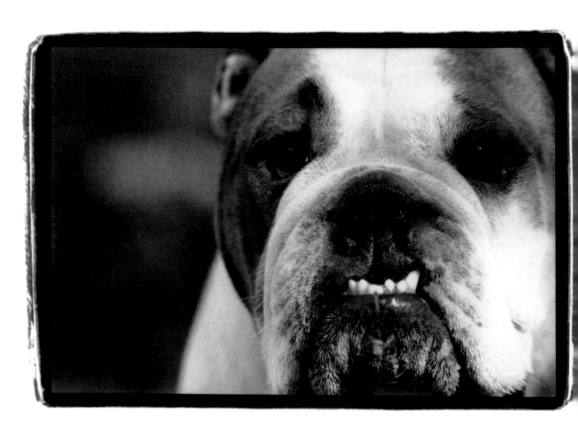

Most of our teeth are still intact.

We acquire that distinguished look . . .

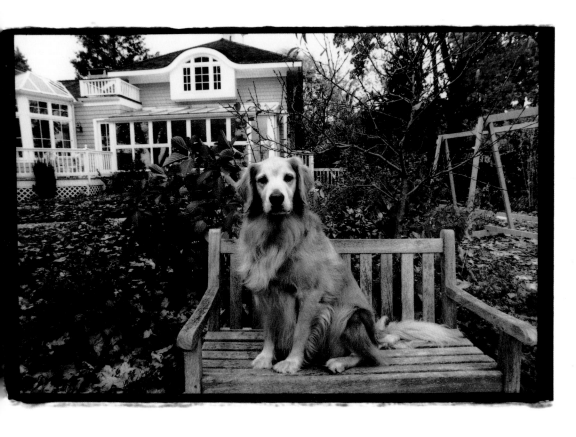

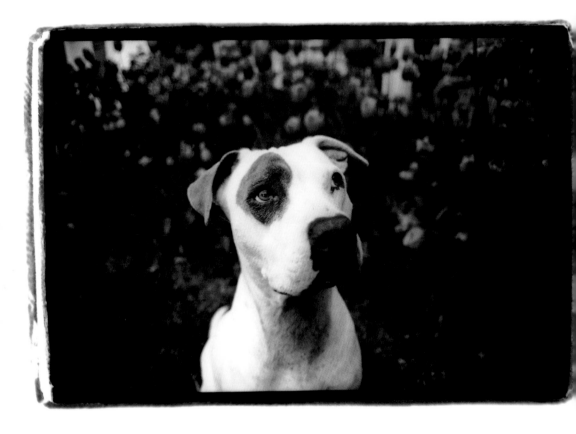

although some of us don't show our age at all.

We enjoy our golden years.

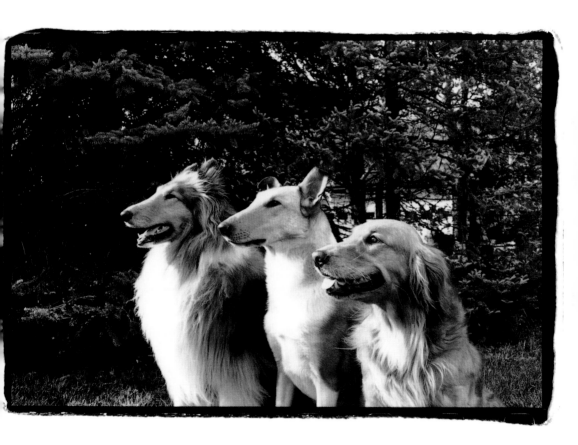

Nostalgia is what we cling to most . . .

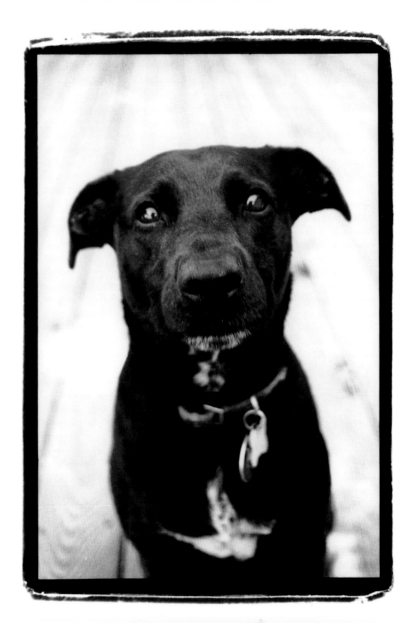

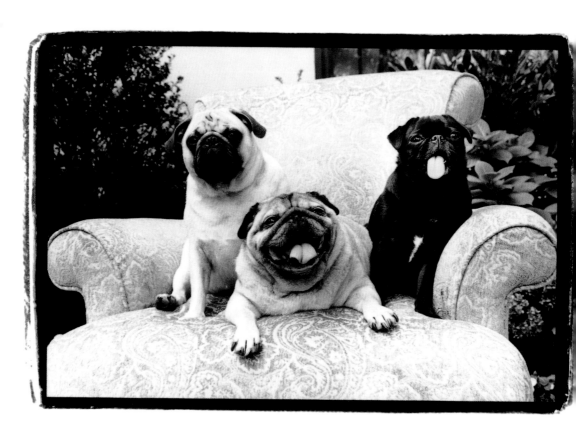

as we reminisce about the "old days."

Hopefully, we can look back on our lives
and laugh a little.

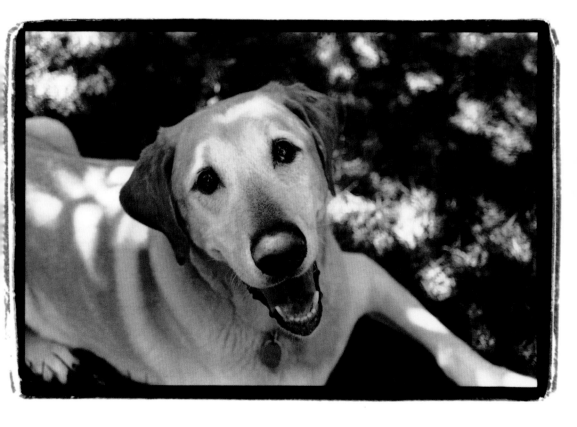

And let's face it . . . some of us never grow up.

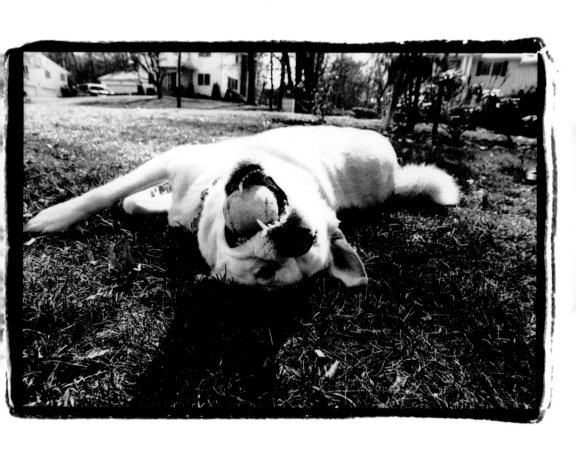

Other Books by
Kim Levin

Dogma (with Erica Salmon)

Why We Love Cats

Why We Love Dogs

Why We Really Love Dogs

Dogs Are Funny

Dogs Love . . .

Working Dogs: Tales from Animal Planet's K-9 to 5 World

Erin Go Bark (with John O'Neill)

For the Love You Give (with John O'Neill)